Piero
della Francesca

The Arezzo Frescoes

By Perry Brooks

Rizzoli Art Series

Series Editor: Norma Broude

Piero
della Francesca
(c.1415/1418–1492)

The Arezzo Frescoes (1452–1466)

Piero della Francesca was born in Sansepolcro, a town on the border of Tuscany and Umbria. He is first recorded as an artist in 1436 for painting insignia on the gates of his hometown along with another painter, Antonio d'Anghiari (perhaps his first teacher). In 1439 he was in Florence in the company of the noted painter Domenico Veneziano. In the 1440s he returned to Sansepolcro, where he was to reside for the rest of his life, sometimes holding important civic and lay religious offices. He fulfilled numerous commissions from religious organizations in Sansepolcro from the 1450s through the 1470s and interrupted his residence there to work in the ducal courts of Ferrara, Rimini, Urbino, the papal court of Rome, in nearby Arezzo, and elsewhere. Piero's style proceeded from the rational study of light and space that the painter Masaccio (1401–1428) had promulgated in the 1420s; in Piero's later works his search to transcribe the subtleties of colored light attracted him increasingly to the Flemish oil painting of Jan van Eyck and his followers. The fresco cycle of the True Cross in Arezzo is his largest surviving pictorial project.

To visit the chapel housing the frescoes of the True Cross in Arezzo you must traverse a simple façade into the darkness of the barnlike nave of the thirteenth-century church of Saint Francis, where—if you come in the afternoon—the southwestern sun flooding the main chapel's Gothic-arched window (deprived now of its colored glass) must be shut out with curtains. Your eyes gradually attune themselves to the counter-light—doubtless helped by a touch of the timed light switch near the offering box—and to the radiance of the light-washed planes frescoed on the chapel walls. With time's relentless consumption, however, the colors before you will seem slightly dimmer this time than the last.[1]

The alternating lights and shadows of this recollected experience seem metaphoric of the historical vicissitudes of Piero della Francesca's critical fortune. As has often been recounted, Piero rose from provincial origins (in the small nearby town of Sansepolcro) to become one of the most illustrious painters on the Italian peninsula in the fifteenth century, as well as a highly regarded expert in perspective and mathematics. Thereafter, however, he lapsed into general obscurity until the nineteenth and twentieth centuries, when his luminous geometric abstraction became a beacon to Post-Impressionist and Post-Cubist viewers. From our vantage point, five hundred years after the artist's death and more than a century after his renewed popularity, in a period when art has largely retreated from the modernist ideals that impelled Piero's reevaluation, this most intellectual and sensuous of fifteenth-century painters still offers ample material for rediscovery and redefinition.

Piero came to maturity in the decade after Masaccio, whose works, such as the Brancacci Chapel fresco cycle in Florence, had depicted a new three-dimensional world founded on the mathematical principles of one-point perspective as defined by the architect Brunelleschi. In his treatise *On Painting* of 1435, the humanist Leon Battista Alberti instructed the Renaissance painter to render with his hand only what he had first grasped with his mind through the discipline of geometry. The new principles offered a convergence of painting and mathematics, two disciplines that exerted a double attraction for Piero from an early age, according to Giorgio Vasari, the sixteenth-century biographer of Italian Renaissance artists. Piero surpassed even Alberti's ideal in the depth of his mathematical researches, and this led to a bifurcation in his later life, when he painted less and wrote more: three treatises on mathematics, of which modern studies have confirmed Vasari's evaluation of Piero as one of the most learned geometers and algebrists of his time.

To Piero the artist, mathematics offered the means of capturing appearance with unprecedented fidelity (through the geometry of light and one-point perspective), of organizing it as spectacle (through harmonic law and geometric idealization), and of passing beyond appearance to a science that, like Leonardo da Vinci's, took as its model the self-gratifying omniscience of God. Nearly forty years ago, an art historian and a mathematician demonstrated that the lucid silence and calibrated visual depths of Piero's famous picture of the Flagellation of Christ (fig. 1) in Urbino are subtended by an intricate network of modules interrelated through the irrational number π in a system not meant especially to satisfy the eyes but rather the mind.[2] Piero, then, might be named the first conceptual artist; but of this intellectual, who died in Sansepolcro at about age seventy-five on the watershed date of October 12, 1492—a last participant in an old order—we can be sure that his concepts were not ours.

The Story of the True Cross in Arezzo, the centerpiece of Piero's artistic production both in terms of chronology and importance, is the artist's only surviving monumental narrative cycle. It illustrates a picturesquely embroidered history of Christ's Cross recounted in *The Golden Legend*, a thirteenth-century compilation of ecclesiastical apocrypha by Jacopo da Voragine:

At the approach of his death, Adam sent Seth to the gates of Paradise to obtain the Oil of Mercy promised as salvation; the angel instead gave a branch which he promised would provide the remedy to human mortality only after the lapse of 5,500 years. Planted on Adam's grave, the sapling grew to become an enormous tree that Solomon desired to use in the Temple; when cut, the wood refused to be fitted into the design by miraculously changing its length, so that the workers cast it over a pond to be used as a footbridge. The Queen of Sheba, on her visit to Solomon, recognized the holy status of the wood, paused in adoration, then prophesized to Solomon that it would bring the end of the Jewish Kingdom. To thwart destiny, Solomon ordered that the wood be submerged (in a spot that became the site of the Probatic Pool because of the wood's therapeutic powers). At the time of Christ's Crucifixion, the wood floated to the surface to be used for the cross and was then reburied with the two thieves' crosses, to lie hidden until the age of Constantine. On the eve of a battle, Constantine had a vision of an angel

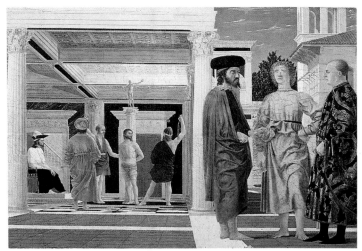

1. *The Flagellation of Christ*. c.1455–1465. Tempera on panel,
23 x 32". Galleria Nazionale, Urbino. Photograph courtesy Alinari/Art
Resource, New York

revealing the cross with the legend "In this sign, you shall
conquer." Carrying the sign into battle, he effortlessly re-
pelled his enemy Maxentius at the banks of the Tiber. He
then sent his mother, Saint Helen, to Jerusalem to find the
True Cross, whose whereabouts were known to a Jew named
Judas. Fearing the revelation would mean the annihilation
of the old Law, Judas refused to speak, whereupon Helen
placed him in a dry well without food or drink. On the sev-
enth day he ceded to her demands and led the empress to
the burial place of the three crosses. After they were uncov-
ered, the True Cross of Christ proved its status by resusci-
tating a young man whose corpse was being carried in a
passing funeral procession. (Judas, according to the story,
then converted, became Archbishop of Jerusalem, and was
martyred by the Emperor Julian.) Saint Helen enshrined the
relic in the Church of the Holy Sepulchre, where it rested
unviolated until the seventh century, when the Persian tyrant
Cosroes looted the church and stole the cross. He set up an
unholy Trinity, by placing the cross as the Son to his right, a
cock as the Holy Spirit to his left, and demanded to be wor-
shiped as the Father in the center. The Byzantine Emperor
Heraclius defeated Cosroes' son in battle, beheaded the
tyrant, then paraded the cross toward Jerusalem on horse-
back with imperial pomp. The gates were barred by an an-
gel, who reminded that Christ had entered in humility on an
ass. When the emperor dismounted and proceeded barefoot,
carrying the cross on his shoulders, the gates were opened.

The Golden Legend, organized according to the feast days
of the Roman Catholic liturgical calendar, recounts the nar-
rative in two sections: the Finding of the Cross, celebrated
annually on May 3rd, traces the vicissitudes of the wood
from Adam's death through Saint Helen's rediscovery; the
Exaltation of the Cross, celebrated on September 14th,
completes the legend with Heraclius' victorious return
of the cross.

The patronage of the chapel at Arezzo involved three
generations of the Bacci, an important Aretine family whose
intentions to decorate the chapel go back to at least 1416.
The patrons and advisers may have selected the subject
matter to adorn the chapel early in the century; the story
was popular and was painted in at least three other Tuscan
churches from this time. No document before 1447, however,
records that the painting of the chapel was in progress. Bicci
di Lorenzo, a seventy-five-year-old Florentine painter whose
old-fashioned style perpetuated formulae of the late trecento,
executed most of the chapel's vault and entrance arch but
was unable to finish because of ill health. He returned to
Florence, where he died in 1452. At some point after Bicci's
departure the Arezzo commission was transferred to Piero,

who completed the frescoes by 1466, which a document of
that date implies.

As a key for understanding the patrons' shift in taste from
the old school Florentine to the avant-garde Piero, the histo-
rian Carlo Ginzburg has underscored the probable influence
of Giovanni Bacci, a cultured member of the third genera-
tion linked to the project who was well-connected with hu-
manist and theological circles in Florence and Rome.
Ginzburg has also suggested the possible intervention
of Cardinal Bessarion, a Greek churchman and Platonist
philosopher, who, favoring union of the Eastern and Western
churches, had settled in Rome, risen to preeminence in
the Latin church, and was appointed protector of the
Franciscan order in 1458. With its cast of repulsed
usurpers and defeated Eastern heretics, the Story of the
True Cross would have acquired new relevance around
1453, when the Ottoman Turks captured Constantinople
and voices began to call for the organization of a new cru-
sade—an ideal promulgated by, among others, Bessarion
and Pope Pius II. Piero's takeover of the commission, then,
might have coincided with a time when its subject matter
was being transformed from a quaint, old-fashioned legend
into the latest allegory of papal politics.

The absence of documents about the Arezzo frescoes ex-
cept those of 1447 and 1466 makes the exact chronology of
Piero's procedure in the chapel difficult to pinpoint. The
artist undertook other commissions within the period and
is documented working in Rome in 1459; various scholars
have seen this as the date by which the frescoes were fin-
ished, the date after which they were started, or a period
of interruption in the work.[3] Piero's other documented com-
missions involve a similar time span, suggesting that pain-
staking preparation and protracted execution were standard
procedure for the artist. Although the painting of the walls
might have taken about two years, the preparation of the
designs would have required much longer, especially since
Piero used the emerging *spolvero* technique, which called
for numerous preparatory drawings (cartoons) scaled to the
size of the final pictures.[4] To construct an absolute chrono-
logical framework for Piero's work on the basis of style alone
is pointless because the majority of his paintings were un-
dated. Pending the appearance of new documents, scholars
can only really keep a sense of possible patterns of interre-
lationship among a multitude of historical and theoretical
variables (including whether the work proceeded down each
wall in turn or continuously around all three walls and down;
whether Piero protracted the painting over the years between
the terminal dates with one or more interruptions or pro-
ceeded in a single concentrated campaign; the extent to
which assistants were involved; and whether an artist's
work necessarily evolves in the direction of twentieth-
century ideas of quality). While one cannot be rigidly
insistent, it seems plausible that Piero started the frescoes
shortly after 1452 and protracted the project into the 1460s,
working down the chapel's three walls; the change from the
supple Hellenic plasticity of the upper right scenes (plates
2 and 4) to the consciously complex and brittle composi-
tions of the lower left (plates 9 and 12) describes a stylistic
trajectory of a decade or more, unified by a constant atten-
tion to varieties of light.

The bold forms of Piero's frescoes suggest a narrative
of geometric permutation independent of the story they

portray (plate 1). The constellation of circles in the church façade of the middle left wall is echoed by the white spheres of the fanciful headdresses in the lower right wall. Teetering diagonals in the lances of the lower sides contrast with bracing columns above and adjacent and conspire with the diagonals of the architecture and crosses of the middle register to suggest privileged points of focus. A common central axis, edged in white, races the eye between the two scenes of the left window wall, while the center of the right wall pulsates between a forward solid on the middle level and a compelling landscape depth below. The repeated crosses on the left wall—hoisted, lowered, triumphally paraded—produce a wheeling kinesthesia. The geometry's exhilarating beat is sustained coloristically by unifying fields of sky blue and rhythmic intervals measured by silvery whites.

A second element providing tonal and architectural unity is the repeated planes of red and black marble, seen in the walls behind the prophet and saint in the lunettes of the window wall, then in the architecture of the second level and of the lower left window wall, and finally echoed with a broader range of color in the dado of fictive marble panels on the lower walls. Unlike other muralists (such as Masaccio, in the Brancacci Chapel), Piero did not provide pilasters or framing elements in the corners of the chapel to accentuate a sense of illusionistic depth. (Perhaps he felt they would clash too violently with the Gothic elements of Bicci's completed vault.) Instead, the scenes run from edge to edge and collide at the corners, calling attention to the discontinuity of place from scene to scene, as well as to the frescoes' ultimate planarity. The predominant architectural element is the horizontal cornice on which each scene seems to rest, linking the scenes on each level around the walls.

The lunettes, representing the Death of Adam on the right (plate 2) and Heraclius' Return of the Cross on the left (plate 3), reflect each other in their pastoral, tree-filled settings, located outside the gates of Paradise and Jerusalem, respectively. In the Death of Adam, the moribund Adam and marvelously aged Eve, on the right, send Seth for the Oil of Mercy, a transaction seen in miniature scale in the distance. On the left, after the disruptive event of the first natural death, Seth bends over to plant the sprig in the mouth of the foreshortened corpse of Adam; mourners react in a circle of stunned suspension and outraged movement, while the great tree that grows from the shoot forms a unifying canopy for the disparate events. In the opposite lunette, the barefoot Heraclius, whose simple dress approximates that of the Adamites, parades the cross toward a portraitlike group of profile adorants, where the centripetal tumult of the opposite wall is replaced by a silence disturbed only by a bystander's obeisant removal of a great conical hat.

In the half-landscape, half-architectural settings of the second register, female regents preside in acts of adoration, with the Queen of Sheba's Visit on the right wall (plate 5) echoing Empress Helen's Finding and Proof of the Cross on the left (plate 11). Half-circled by a splendidly fashionable retinue of ladies-in-waiting, the Queen of Sheba drops in prophetic recognition of the Wood of the Cross in the bridge that spans an elided pond. A row of Corinthian columns that Vasari called "divinely measured" segregates the marble portico, where, surrounded by a symmetry of male and female attendants, the queen and Solomon grasp their right hands in an ancient marriage gesture thought to be symbolic

of fifteenth-century hopes for the reunification of the Eastern and Western churches.

On the opposite wall Saint Helen oversees the recovery of the crosses. She stands against an agrarian landscape whose sense of depth was originally intensified by details of vegetation studding the distant hills (now visible only through ultraviolet photography[5]). Across a spatial elision spanned by a maid-of-honor's drapery overlapping a worker's foot, the Proof of the True Cross is witnessed by another of the monumental circular groupings that Piero derived from Masaccio; here the figural architecture reiterates in three dimensions the leitmotif of the elegant temple façade.

Both the compositions of this middle register recall the interest in perspective and architecture evident in Piero's painting of the Flagellation; as in that painting (and contrary to Masaccio's practice in the Brancacci Chapel or Alberti's prescriptions in *On Painting*), the point of view, while centralized, is not even with the eye-level of the depicted characters, but is low, at a level approximately signaled by the half-figure of the worker in the trench of the Finding of the Cross. Although Piero usually planned his compositions with the vanishing point separate from the center of narrative interest, in the Sheba scene the vanishing point is within her realm of adoration, and it could be that the artist was suggesting his construction was a second object of that adoration.

The two scenes of the window wall show the subsequent and prior moments to the events of the side walls, in genre-like portrayals executed after Piero's designs by an assistant identified as Giovanni da Piamonte. To the right of the window (plate 7) workers haul the wood in conscious response to Solomon's command to bury it, an unwitting foreshadowing of Christ's journey to Calvary. Descriptions of this scene, incidentally, consistently misidentify the objects in the lower-left corner as a bone-filled pit, a mouth of hell, or an orange-rimmed pool. The true identity of these objects is much more commonplace: the scalloped, foreshortened edge of the pleated apron of one of the workers, bundled with a white-lined orange jacket lying adjacent to a flat-brimmed hat like those of Sheba's grooms.

On the other side of the window (plate 6), Judas, prepared to reveal the crosses' location after his seven-day ordeal, is hoisted from the torture chamber of the dry well on the eve of the conversion that he will undergo after witnessing the True Cross's miraculous power. He is aided by a figure wearing a hat with a tiny inscription, of uncertain legibility but perhaps to be translated, "With prudence I conquer" (suggesting that the similarly clad youths of this register were intended as a covert chorus of the cardinal virtues, with Prudence of Judas' decision joined by Fortitude in the straining laborers and Temperance in the bridle-clutching, lash-bearing groom; the series awaits completion in the Justice to be meted to Cosroes on the level below). This scene is notable as it is the only scene in the cycle in which the source of light does not correspond to the natural light emanating from the window in the chapel, but instead is reversed, here falling from the upper left.

The two scenes on the lower register of the window wall illustrate the deliverance of divinely ordained announcements by angelic messengers. On the left, the Annunciation to Mary of the Incarnation of Christ (plate 9), which falls outside the episodes of the Story of the Cross narrated in

The Golden Legend on the feast days of the Invention and Exaltation, marks the opening of the gates of Paradise that had been shut with Adam and Eve's Expulsion. Celebrated on March 25th, also believed to be the date of Adam's death, it recalls the lunette of the right wall. Striding before the closed door—symbolizing Mary's virginity—the palm-bearing Gabriel alludes to the gift of the branch delivered by the angel in that lunette.[6] The image's structure of light and shadow suggests the description of the Annunciation in the March 25th festival of *The Golden Legend*, which, following Luke 1:35, speaks of the Virgin being overshadowed by the power of divinity. Piero created a graphic light metaphor to symbolize the marriage of divinity and humanity, in the detail of the shadow projected by the pole in the upper right, which falls precisely through the loop of the torch holder.[7] Piero also marked the higher sanctity of this scene by shortening the pictorial field (filling out the lower edge with a strip of maroon and neutral gray) so that the proportion of height to width closely approximates the "divine proportion" of the golden section (approximately 8:5).

On the right (plate 10), the Dream of Constantine occurs in the black of night, in a virtuoso exploration of the theme of the nocturne (pioneered in Italy by Pietro Lorenzetti and Taddeo Gaddi in the fourteenth century, and revived by Lorenzo Monaco and Gentile da Fabriano in the early fifteenth century). The foreshortened angelic messenger swoops in from above bearing—with pinky delicately extended—a tiny cross, whose radiance is the painting's source of light.

The immediately adjacent scene on the right wall (plate 8) contrasts dawn with midnight, as Constantine leads a splendid cavalry amid a spectacle of banners and lances and, with a cross whose size is in reverse proportion to its brilliance, repulses Maxentius across an abbreviated stream that affords a view into a light-filled landscape.

In the lower register of the opposite wall (plate 12), luminous interval and bloodless victory are replaced by compacted mass and congealed violence, in the battle between Heraclius and Cosroes' son. At the right Cosroes, removed from his blasphemous Trinitarian stage and still bearing the features of God the Father (seen diagonally above him in the adjoining Annunciation), awaits decapitation amid a circle of witnesses, while the hindquarters of a brown horse deliver an irreverent salute. The horse's rider, Cosroes' son, dies with a dagger to the neck at the foot of the cross his father has profaned. At exactly the central axis of the panel, in a rude introversion of the attraction of the perspectival vanishing point, a single warrior, struck by a similar blow, throws the viewer a complacent and complicitous gaze. The descent of the walls ends in the brutal presence of war's inevitability.

Escape from this infernal zone is effected through larger organizational patterns: the blasphemer's dying son—from whose mouth the cross seems to emerge at death, in an inversion of the shoot planted in the mouth of the dead father in the diagonally related lunette of the Death of Adam—is placed immediately below the resurrected son in the scene above, and this rising axis culminates in the protective walls of Jerusalem in the lunette.[8] Piero's cycle abounds with such echoes and reflections—thematic, liturgical, and formal— in a dense network that crosses horizontally, vertically, and diagonally.[9]

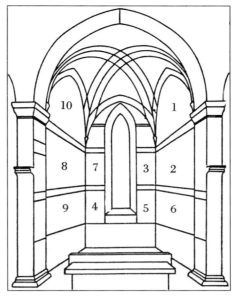

2. Chronological sequence of the fresco cycle
Legend of the True Cross. Main chapel of
S. Francesco, Arezzo

However, the chronological thread of the story, its succession in history (fig. 2) becomes lost in this web; the idiosyncratically serpentine course of this sequence has been a standing source of puzzlement. One recent commentator has shown that such idiosyncrasies are not unprecedented; another has shrewdly suggested that Piero was giving pictorial expression to the very unclarity of the story told in Jacopo da Voragine's text (which is filled with constant qualifications, second versions, and intimations of *déjà vu*) and to a philosophy of the uncertain visibility and comprehensibility of history for humankind.[10] Yet I believe it can be shown that Piero structured the chronological sequence according to a rational plan that is revealed only by leaving the uncertainty of vision for the certainty of mathematics.

This rationale is based on Pythagorean number theory, which became institutionalized in the structure of mathematics as it was taught in the Middle Ages and Renaissance through Boethius' *Arithmetic*, a fifth-century Latin translation of an earlier Greek treatise by the Neo-Pythagorean writer Nicomachus of Gerasa. Number, in this ancient theory, was distinguished according to "multitude"—discontinuous aggregates of units, as in a flock, or a heap—and "magnitude"—continuous and extended quantities, as in a drawn line. The quadrivium, or four-part division of the mathematical disciplines, was determined by this distinction between discontinuous and continuous quantity: Arithmetic treated multitude in itself, Music treated relative multitude (in the harmonic ratios), Geometry treated static magnitude, and Astronomy treated magnitude in motion. Arithmetic, called the pattern of God's thought, was considered more elemental and archetypal than Geometry (just as, for instance, the condensed concept of three would seem to precede the spatially extended geometric figure of the triangle); this theory developed in tandem with a Neoplatonic outlook that prized unity over multiplicity and idea over matter.

Arithmetical precedence for geometric shapes was demonstrated in the Pythagorean theory of the "planar" or "polygonal" numbers, in which units are configured into geometrical shapes. The simplest are the triangular numbers (1, 3, 6, 10, 15, 21, etc.), the square numbers (1, 4, 9, 16, 25, 36, etc.), and the pentagonal numbers (1, 5, 12, 22, 35, etc.), configured through units (signified in Boethius' text by the Roman numeral "I") as follows:

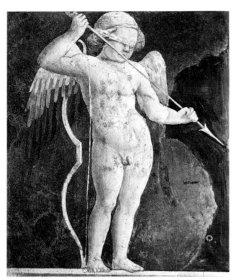

3. *The Blindfolded Cupid.* c.1452–1466.
Fresco, base 28". S. Francesco, Arezzo.
Photograph courtesy Alinari/Art Resource,
New York

Triangular Numbers

1)	I	3)	I	6)	I	10)	I
			I I		I I		I I
					I I I		I I I
							I I I I

Square Numbers

1)	I	4)	I I	9)	I I I	16)	I I I I
			I I		I I I		I I I I
					I I I		I I I I
							I I I I

Pentagonal Numbers

1)	I	5)	I	12)	I	22)	I
			I I		I I		I I
			I I		I I I		I I I
					I I I		I I I I
					I I I		I I I I
							I I I I
							I I I I

Conceived less as visible shapes for the eye than as conceptual patterns for the intellect, each of these number series was defined by its *gnomon*, or principle of incrementation and growth, which for the triangular numbers is the successive integers added in horizontal strata, and for the square numbers the successive odd numbers joined in a right-angled pattern, as seen in the following diagrams:

Gnomons Gnomons

1	I		1	I	I	I
2	I I		3	I	I	I
3	I I I		5	I	I	I

The pentagonal gnomons are more complex to explain; one may simply note that each pentagonal number is the offspring of a triangle and a square (e.g., 5 = 1+4, 12 = 3+9, 22 = 6+16), just as each square is the offspring of two triangles (e.g., 4 = 1+3, 9 = 3+6, 16 = 6+10, etc.).

The narrative time of the Arezzo frescoes is ordered according to this discontinuous, planar model (appropriate to the episodic nature of the story of the True Cross, and harmonious with the visual planarity of the frescoes) in a conceptual structure ideally articulated, according to the chronological order of each scene, in the following right-to-left diagram (fig. 2):

```
   10                                           1
  8 7        <——      8 7        <——          3 2
  9 4                 9 4                      4 5 6
```

In the first six scenes, the sedimentation of Christian history follows the mathematical laws of the triangular gnomons, with each level of the progression marking a stage of divine dispensation: before the Mosaic Law, in the single scene of Adam's death; under the Law, in the two panels of the reign of Solomon; and under Grace, in the first three scenes of the Christian Era. The prominent diagonal of the beam in the Burial of the Wood subtly directs the triangular order of reading.

The cycle is also structured into two zones by the axis of the window: all the scenes to the right of the window represent pre-Christian heroes—*The Golden Legend* stresses that Constantine was not yet converted at the time of the battle portrayed—while all the heroes to the left are Christians; this is signaled by a prophet (plate 4) in the right lunette of the window wall and a saint in the left.[11] The next three scenes after the sixth unfold to the left of the window in the right-angled pattern of the square gnomons; they take as their cornerstone scene 4, the Annunciation/Incarnation, which crosses the window axis, inaugurates the realm *sub gratia*, and offers the pattern for a new order. The ascent from the ninth to the tenth scene can be read as the pentagonal capstone to the numerical conceit in a three-part sequence that is also metaphoric of past, present, and future.

This sequence of triangle to square to pentagon might fall under the reign of another of the most puzzling details of the chapel, namely the intrusion in a Christian chapel of the blindfolded Cupid (fig. 3) on the upper left pier. Representing less a pagan deity than a personified idea, he was probably meant to rule over the marriage gesture of Solomon and Sheba's meeting on the right wall and the union of God and Mary on the window wall in the Annunciation (the scene linking triangle and square). The arithmetical sequence conforms to the nuptial resonance of these details, if interpreted in the light of a tradition of Pythagorean discourse in which numbers are gendered (even is female and odd is male) and synthetic arithmetical and geometrical figures are identified as "nuptial." In late antiquity, Plutarch offered several statements of these ideas, which were transmitted into the Middle Ages by writers such as Martianus Cappella. Plutarch writes, for instance, of the number five: "Since . . . every number may be classified as even or odd . . . and since two makes the first of the even numbers and three the first of the odd, and five is produced by the union of these numbers, very naturally five has come to be honored as the first number created out of the first numbers; and it has received the name of 'marriage' because of the resemblance of the even number to the female and of the odd number to the male."[12] Plutarch allegorized the geometric figure of the 3-4-5 Pythagorean triangle in identical terms, recounting that the ancient Egyptians identified 3 with the father Osiris, 4 with the mother Isis, and 5 with the child Horus.[13] These ideas passed into pedagogic tradition, where the Pythagorean theorem became known as the "Theorem of the Bride" or the "Bride's Chair."[14]

Indeed, the engendered pattern of the pentagonal numbers could be regarded as the mathematical archetype for the very shape of the Arezzo chapel walls and for the composition of the right wall, with its tree-centered, near triangular lunette topping two horizontal panels, each cleft by a strong caesura. Perhaps it was in facing the problem of this unchangeable architectural given—considering its old-fashioned Gothic

4. *Portrait of Piero della Francesca* from
Giorgio Vasari's *Lives of the Artists*. Published
1568. Woodcut

shape, and breaking it down to its arithmetical "parents" of square and triangle—that the artist arrived at the order of his narrative progression. Piero, or else the anonymous iconographic advisor to the project (a role for which Ginzburg has nominated the Platonist Bessarion), thus underpinned the chapel's visible walls with an arithmetical model of cosmic generation, in striking accord with the words of Plato: "The origin of each thing takes place . . . when a first principle, taking on increment, passes into its second transformation and from this to its neighbor, and having made three transformations makes perception possible to those who perceive it."[15]

The scene above the seminal Annunciation incorporates an interesting biographical postscript to the chapel's theme of generation: the figure of Judas (plate 6) drawn from the well after his torture and prior to his conversion seems the most likely in the cycle to be identified as a portrait of Piero della Francesca. Not only the general features of face and hair, but especially the telling detail of the cleft chin are nearly identical to the woodcut portrait in Vasari's *Lives* (fig. 4) and to a recently identified posthumous portrait in the stained glass window of the church at Arezzo created by Guillaume de Marcillat in the 1520s.[16] The repentant Judas emerges from his underground prison along the umbilical axis of the edge of the Madonna's house, which elides into the edge of the hoist behind him (plate 1); he is the microcosmic image of *renaissance*.

NOTES

1. The poor condition of the frescoes, plagued by chemical changes that convert the plaster to chalk and by saline efflorescences caused by water seepage through the walls, has been the subject of intense recent study; cf. Lenzini in Guillaud.
2. R. Wittkower and B. A. R. Carter, "The Perspective of Piero della Francesca's 'Flagellation,'" in *Journal of the Warburg and Courtauld Institutes*, XVI (1953), pp. 292–302.
3. For a summary of arguments, see Borsook, pp. 92 ff. Ginzburg, p. 43ff., argues from historical and iconographical reasons for the completion of the scenes below the lunettes after 1459. L. Bellosi argues for completion by 1459 in "Giovanni di Piamonte e gli affreschi di Piero ad Arezzo," in *Prospettiva* 50 (1987), pp. 15–35.
4. These cartoons were pricked along the contours, then dusted with charcoal, which passed through to the wet plaster, producing dotted outlines (visible in the finished frescoes) to guide the technique, which combined true fresco—i.e., water-based pigments applied to wet plaster—with oils and tempera and painted *a secco* onto dry plaster. Cf. Borsook, p. 97, and Lenzini in Guillaud.
5. See Guillaud, p. 86.
6. Observed by Rainer Kahsnitz; see Borsook, p.94.
7. Observed by Howard Davis; see Schneider (1985).
8. The relation to the Death of Adam is noted by D. Arasse, "Piero della Francesca, peintre d'histoire?" in O. Calabrese, *Piero, Teorico dell'Arte* (Rome: Gangemi, 1985) p. 98; "The Relation to the Proof of the Cross," by M. Podro, *Piero della Francesca's Legend of the True Cross* (Newcastle-upon-Tyne: University of Newcastle-upon-Tyne, 1974), p. 20.

9. Cf. Schneider (1969); C. Gilbert, *Change in Piero della Francesca* (Locust Valley, New York: J.J. Augustin, 1968), pp. 77–79; L. Marin, "La Théorie narrative et Piero peintre d'histoire," in Calabrese, pp. 55–84; Lavin, pp. 167–194 and *passim*.
10. Lavin, *passim*; Arasse in Calabrese, p. 101.
11. Gilbert, pp. 77–78.
12. *De E apud Delphos*, in *Moralia*, trans. F. D. Babbitt (Cambridge, Mass.: Harvard University Press, 1957), V, p. 217.
13. *De Iside et Osiride*, in *Moralia*, V, p. 135.
14. T. Heath, *The Thirteen Books of Euclid's Elements* (2nd. ed., 1926; reprint, New York: Dover, 1956), I, pp. 417–418.
15. *Laws*, 894 a, quoted in W. Burkert, *Lore and Science in Ancient Pythagoreanism*, trans. E. L. Minar (Cambridge, Mass.: Harvard University Press, 1972), p. 26.
16. Identified by Father G. Renzi; see G. Centauro, *Dipinti murali di Piero della Francesca, La basilica di S. Francesco ad Arezzo: Indagini su sette secoli* (Milan: Electa, 1990), p. 8.

FURTHER READING

Borsook, Eve. *The Mural Painters of Tuscany*. 2nd ed. Oxford: Clarendon Press, 1980.

Brooks, Perry. *Ut Pictura Mathesis: Studies in the Art of Piero della Francesca*. Ph.D. Dissertation. Columbia University, 1990.

Clark, Kenneth. *Piero della Francesca*. 2nd ed. London: Phaidon, 1969.

Ginzburg, Carlo. *The Enigma of Piero*. London: Verso, 1985.

Guillaud, Jacqueline, and Maurice, with Margherita Moriondo Lenzini. *Piero della Francesca, Poet of Form: The Frescos* [sic] *of San Francesco di Arezzo*. New York: Clarkson N. Potter, 1988.

Jacopo da Voragine. *The Golden Legend of Jacobus da Voragine*. Edited and translated by Granger Ryan and Helmut Ripperger. New York: Longmans, 1941.

Lavin, Marilyn Aronberg. *The Place of Narrative: Mural Decoration in Italian Churches, 431–1600*. Chicago: University of Chicago Press, 1990.

Schneider, Laurie. "The Iconography of Piero della Francesca's Frescoes Illustrating the Legend of the True Cross in the Church of San Francesco in Arezzo," in *Art Quarterly*, 32 (1969), pp. 23–48.

_____. "Shadow Metaphors and Piero della Francesca's Arezzo *Annunciation*," in *Source* 5 (1985), pp. 18–22.

First published in 1992 in the United States of America by Rizzoli International Publications, Inc.
300 Park Avenue South
New York, New York 10010

Copyright ©1992 Rizzoli International Publications, Inc.
Text copyright ©1992 Perry Brooks

Library of Congress Cataloging-in-Publication Data
Brooks, Perry
 Piero della Francesca/Perry Brooks
 p. cm.—(Rizzoli art series)
 Includes bibliographies.
 ISBN 0-8478-1513-7
 1. Piero, della Francesca, 1415/18–1492—Criticism and interpretation.
I. Title. II. Series.
ND623.P548B7 1992 91-41027
759.5—dc20 CIP

Series Editor: Norma Broude
Series designed by José Conde and Betty Lew/Rizzoli

Printed in Singapore

Front cover: see colorplate 5

Index to Colorplates

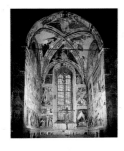

1. *Main chapel of S. Francesco, Arezzo.*
The side walls of the chapel measure approximately 22½ feet wide and 45 feet high. Bicci di Lorenzo painted the vault with the four evangelists against a starry blue field.

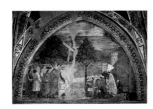

2. *Death of Adam.* c.1452–1466.
The mastery of motion and anatomy in the nudes (of which many prototypes in Greco-Roman art have been cited) parallels and prefigures trends in Florentine art. The leaves of the tree, originally painted *a secco*, have flaked off, leaving only the aura of their presence.

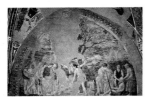

3. *Heraclius' Return of the Cross to Jerusalem.* c.1452–1466.
The loss of unifying details of landscape vegetation and the vertical patch at middle left have weakened the coherence of this composition, based on the play of opposing diagonals against verticals and the steep drop in height from the exalted cross to the kneeling adorants.

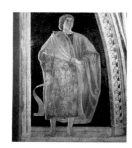

4. *Prophet.* c.1452–1466.
The secondary reflections along the side of the head turned away from the light reveal the subtlety of Piero's depiction. The fluttering scroll, with its mathematically plotted curves, is a tour de force of three-dimensional description and two-dimensional decoration.

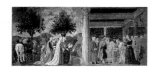

5. *The Queen of Sheba's Visit to Solomon.* c.1452–1466.
The highly schematized cross-symmetries of color in the livery of the two grooms at the left set the tone for the ordered formal etiquette of this courtly scene. Piero gave the design a sense of heraldic closure by taking some of the cartoons used in the female retinue on the left and reusing them in reverse on the right.

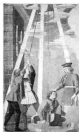

6 and 7. *The Extraction of Judas from the Well* and *The Burial of the Wood.* c.1452–1466.
The execution of these two scenes is credited to Giovanni da Piamonte, who gave the guidelines of Piero's cartoons for locks of hair a heavy linear translation and a somewhat Medusan cast. (Giovanni also painted the saint of the left window lunette and the clumsy horses at the left of *The Queen of Sheba's Visit*.) They interact diagonally with the scenes directly below, as the hoist of Judas' Extraction echoes the conical form of Constantine's tent (plate 10), and diagonally the beam of the Burial leads the eye to the Annunciation (plate 9).

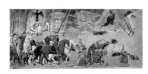

8. *The Victory of Constantine over Maxentius.* c.1452–1466.
The luminosity of this scene reveals Piero's desire to render, in his mixed fresco technique, effects previously conveyed only in Flemish oil painting. Constantine bears the features of the Byzantine Emperor John VIII Palaeologus, presumably in promotion of the ideal of a Crusade to expel the Turks from Constantinople.

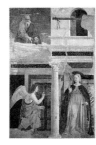

9. *The Annunciation.* c.1452–1466.
Compared to the scenes in the upper registers, *The Annunciation* shows an intensified interest (fostered by the experience of Flemish painting) in the optical description of particularized patterns and textures—the sheer fabric of Gabriel's shirt, the pearl edging and fuzzy lining of the Madonna's mantle, the intricate geometric intarsia on the door panels, the decorative inlays of the bedchamber, etc.

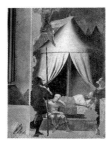

10. *The Dream of Constantine.* c.1452–1466.
Beyond its dramatic function, the night sky serves to harmonize Bicci di Lorenzo's starry vault, just as the contours of the tent reflect the shape of the walls and invert the cusps of the Gothic arches of the vaults; see also plate 1.

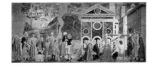

11. *The Finding and Proof of the True Cross.* c.1452–1466.
The elegant temple façade is a precocious visualization of Renaissance architectural principles. The view into the city street is calculated to offer a plunge into depth, but also to measure two-dimensional white stripes that echo the white timbers of the hoist in the adjoining scene (plate 6).

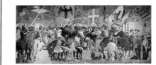

12. *The Victory of Heraclius over Cosroes.* c.1452–1466.
The congested *horror vacui* of Roman battle sarcophagi inspired the self-devouring phalanx of warriors in this scene. Vasari noted the presence of several portraits of members of the Bacci family in the circle of magistrates at the right.

13. *View of Arezzo* (detail of plate 11). c.1452–1466.
This "harmony in white, terra-cotta, and slate" suggests the reasons for Piero della Francesca's appeal to the generation of Picasso and Mondrian. The church of S. Francesco looms at middle right.

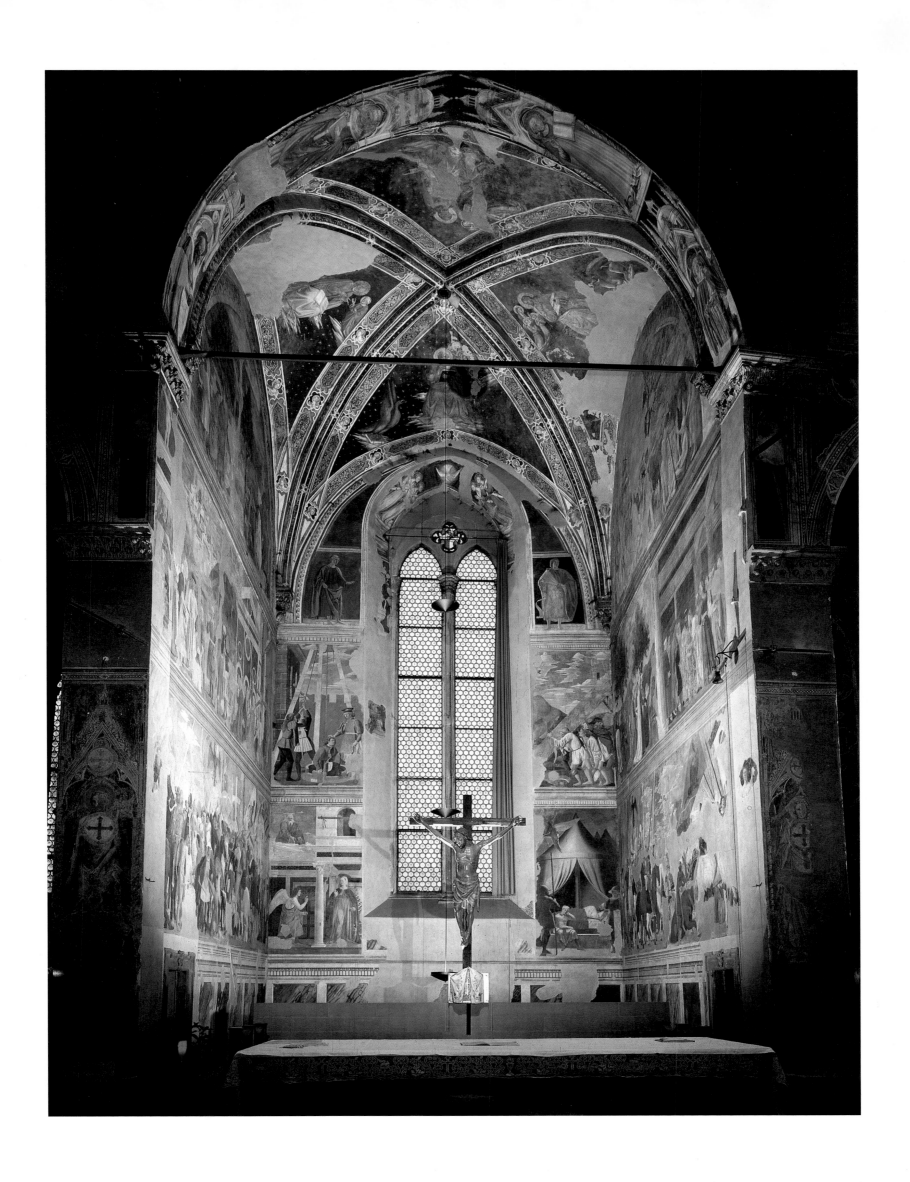

1. Main chapel of S. Francesco, Arezzo with fresco cycle *Legend of the True Cross* (frontal view).
Photograph courtesy Scala/Art Resource, New York

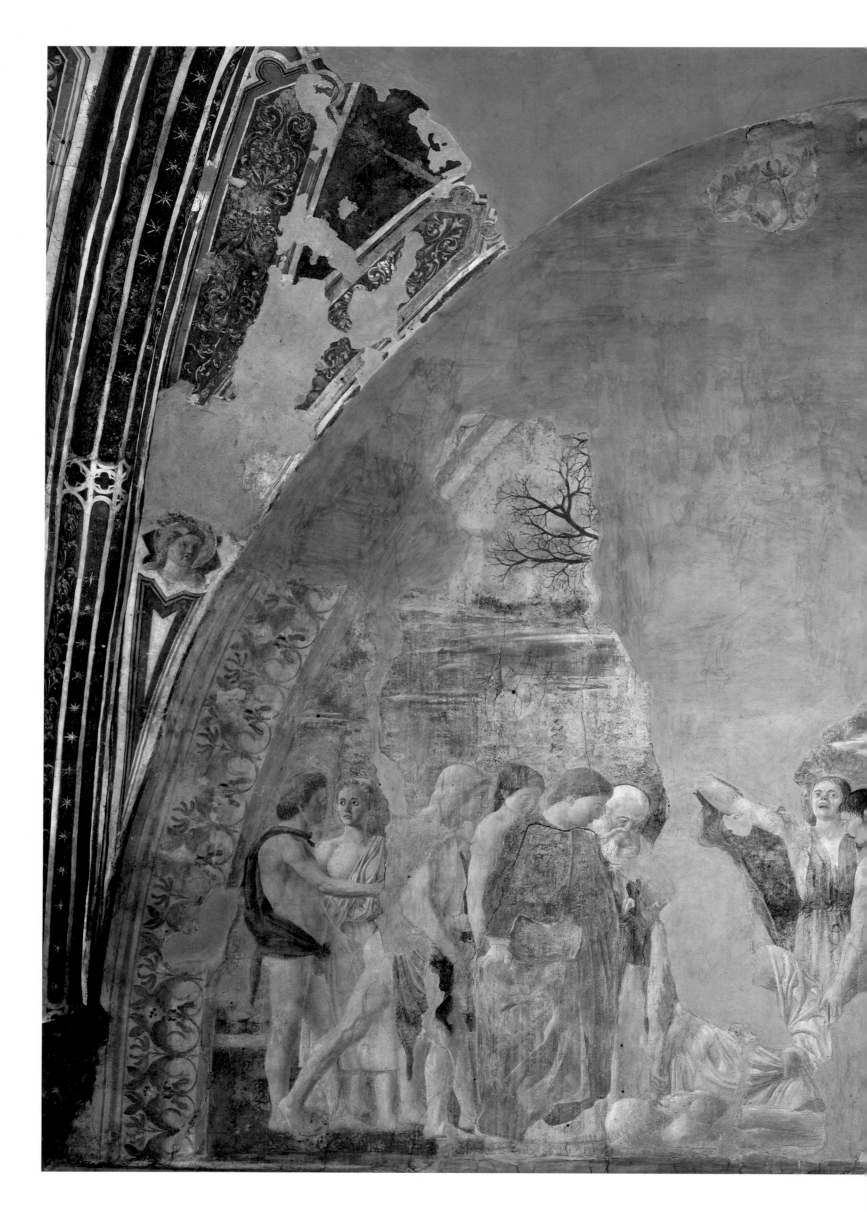

2. Death of Adam. c.1452–1466. Fresco, 154 x 294". S. Francesco, Arezzo.

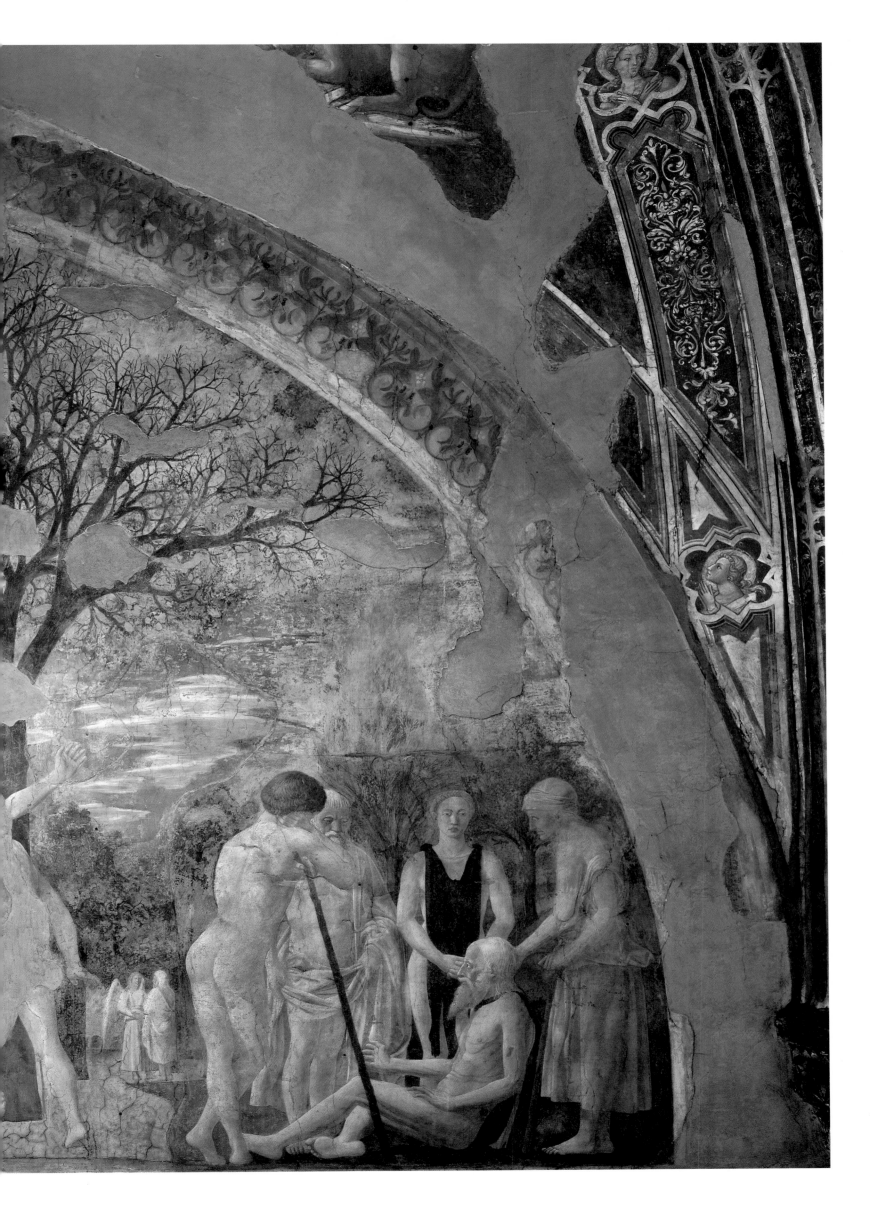

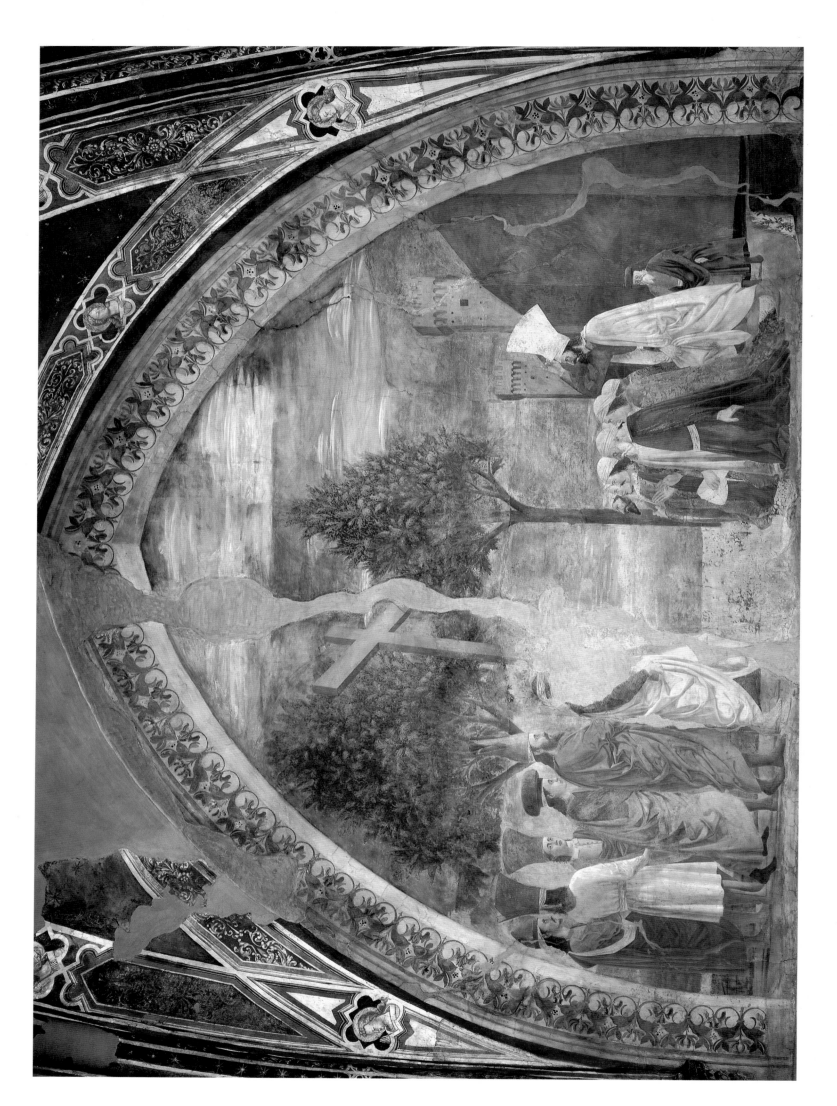

3. *Heraclius' Return of the Cross to Jerusalem.* c.1452–1466. Fresco, 154 x 294". S. Francesco, Arezzo. Photograph courtesy Scala/Art Resource, New York

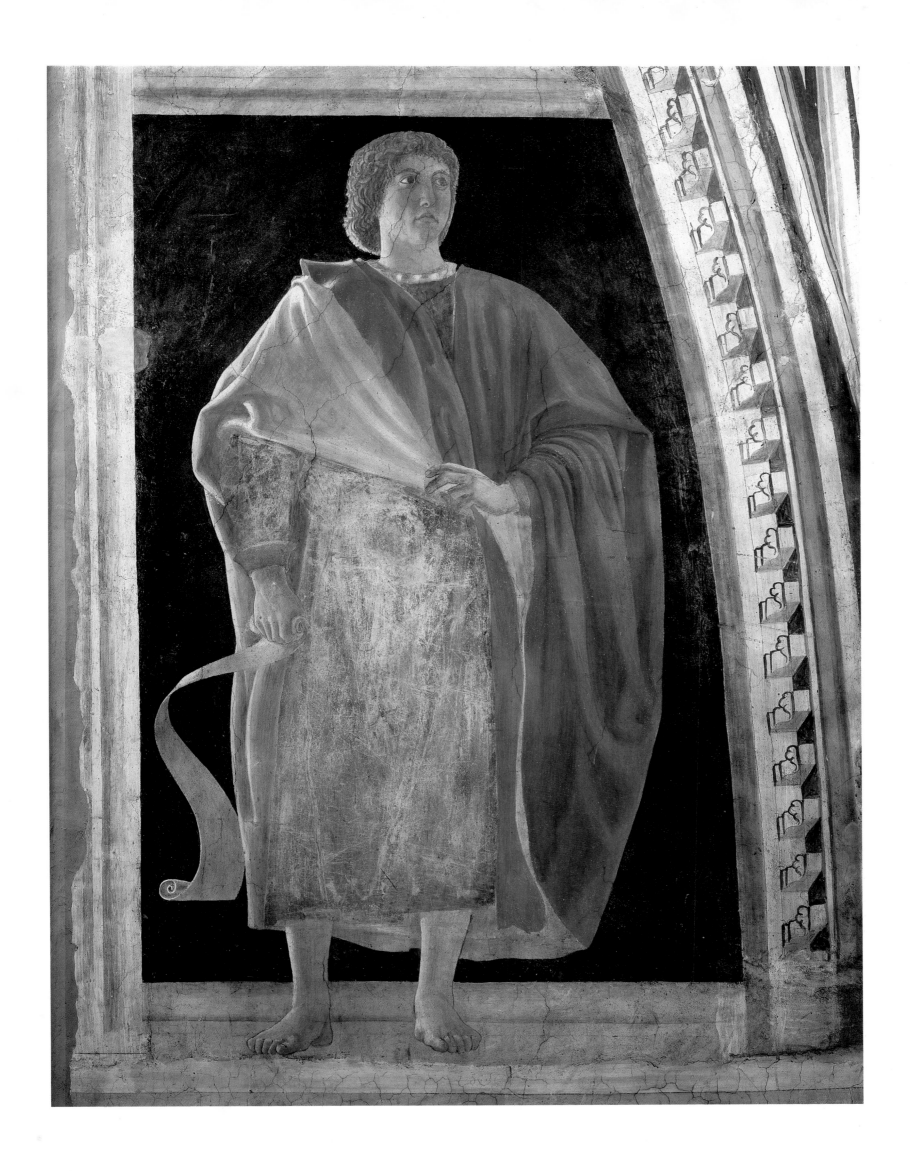

4. *Prophet.* c.1452–1466. Fresco, width of base 75". S. Francesco, Arezzo.
Photograph courtesy Scala/Art Resource, New York

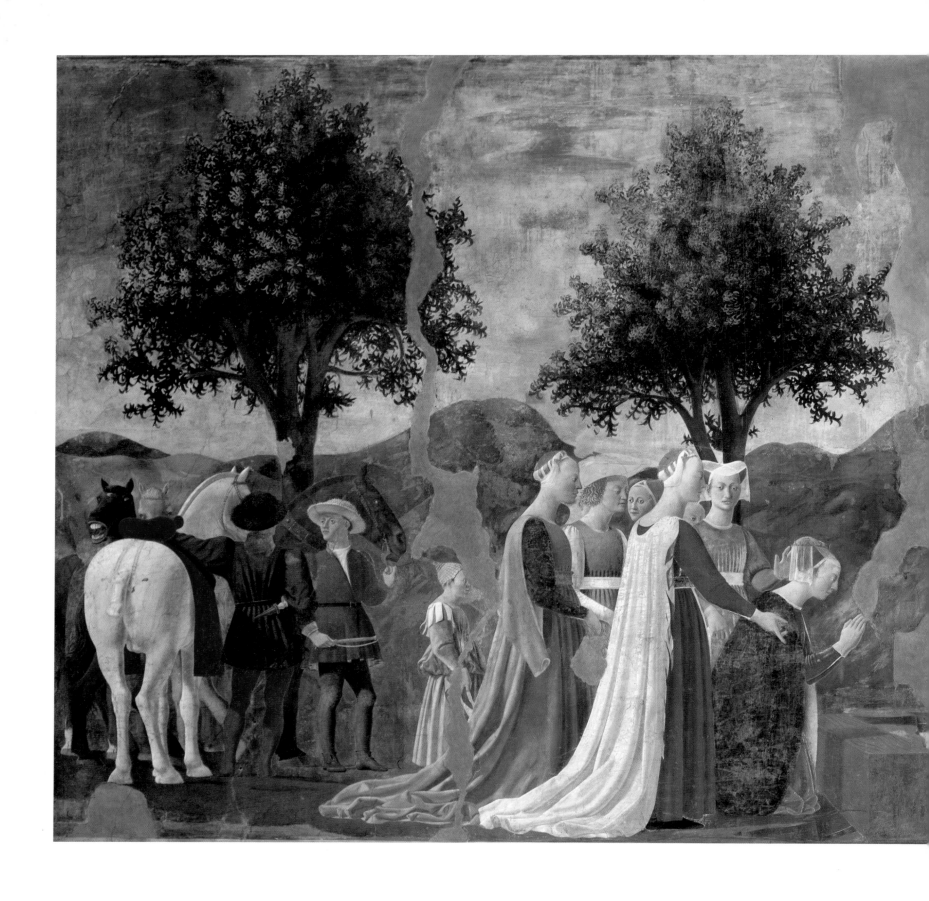

5. *The Queen of Sheba's Visit to Solomon.* c.1452–1466, Fresco, 132 x 294". S. Francesco, Arezzo.

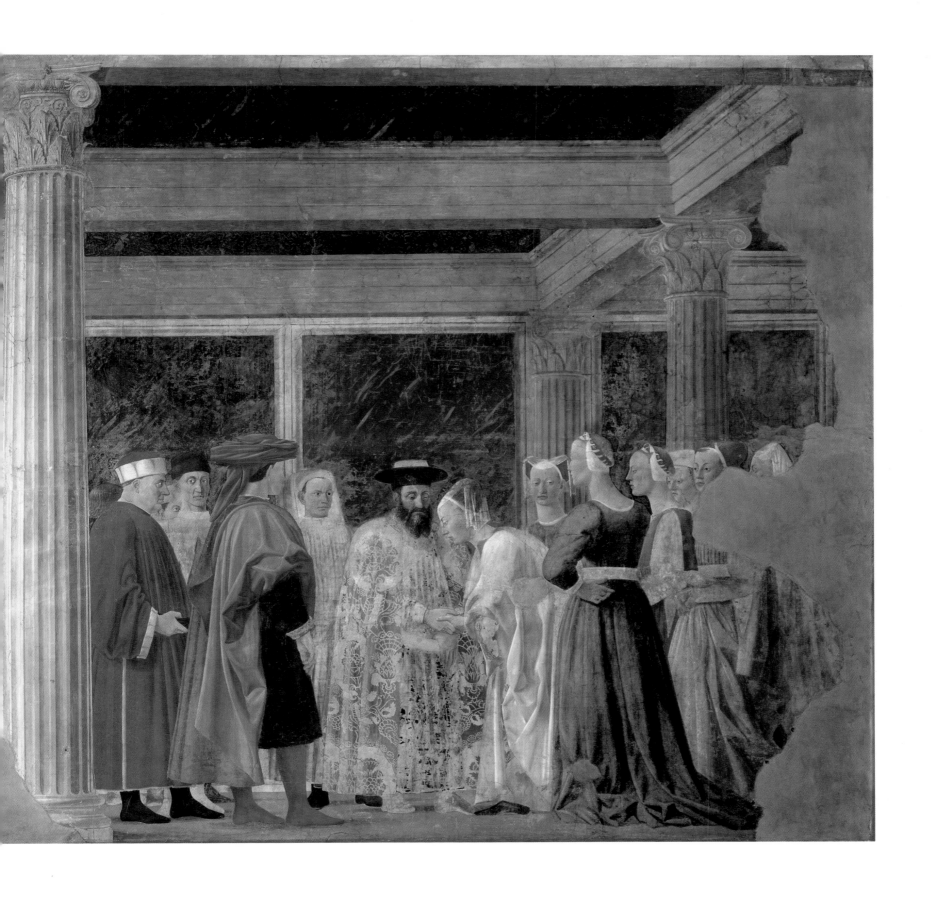

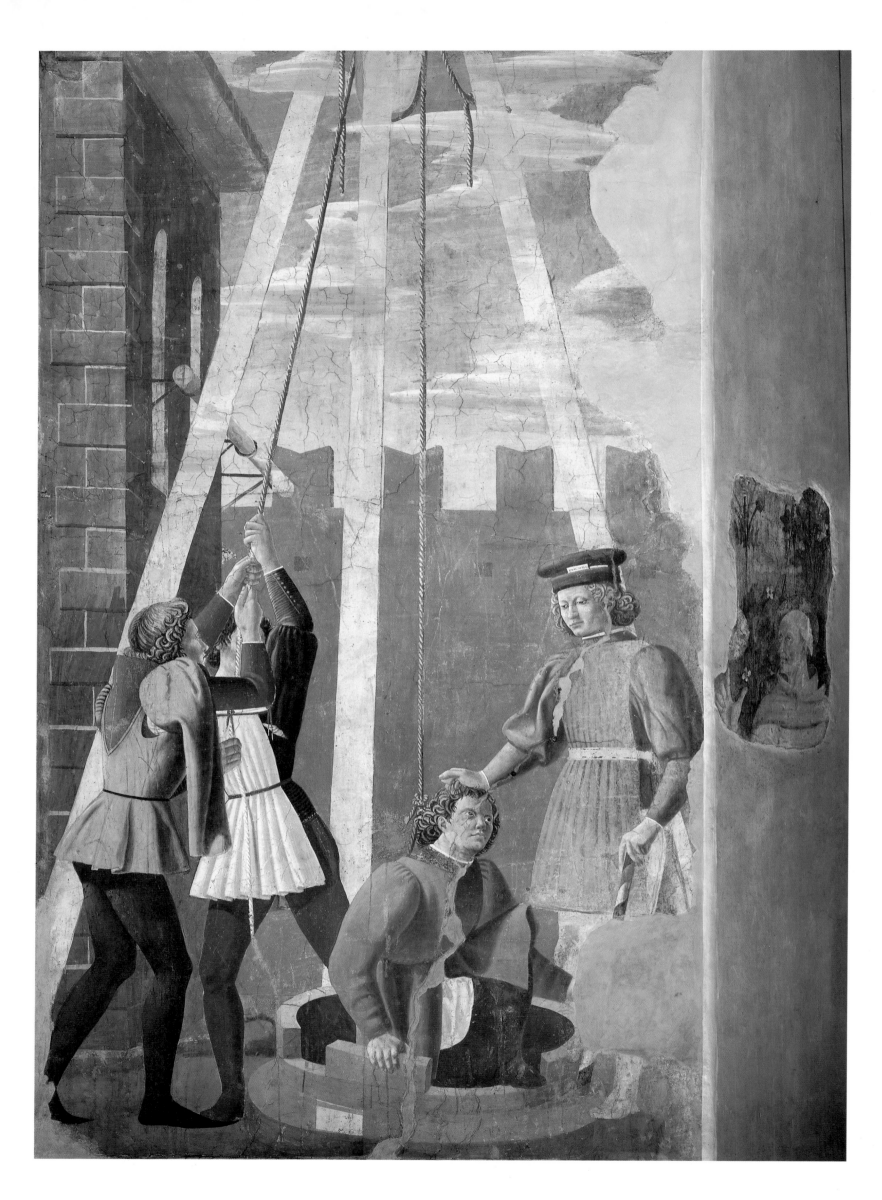

6. *The Extraction of Judas from the Well*. c.1452–1466. Fresco, 140 x 76". S. Francesco, Arezzo.
Photograph courtesy Scala/Art Resource, New York

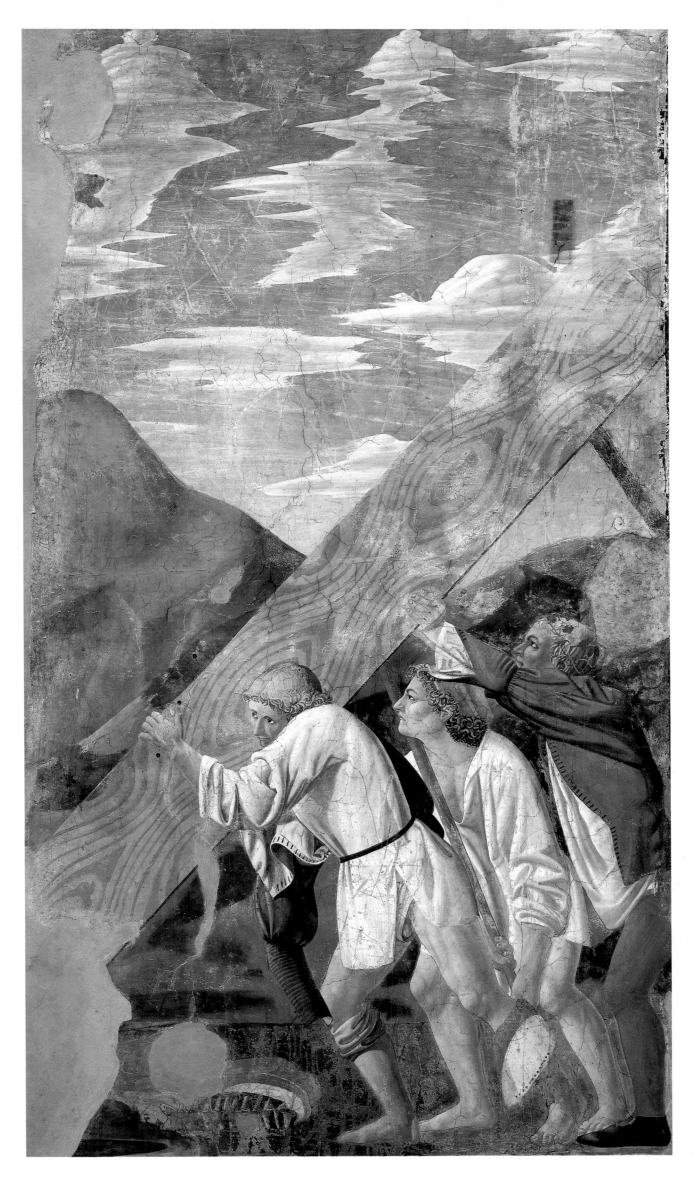

7. *The Burial of the Wood.* c.1452–1466. Fresco, 140 x 75". S. Francesco, Arezzo.
Photograph courtesy Scala/Art Resource, New York

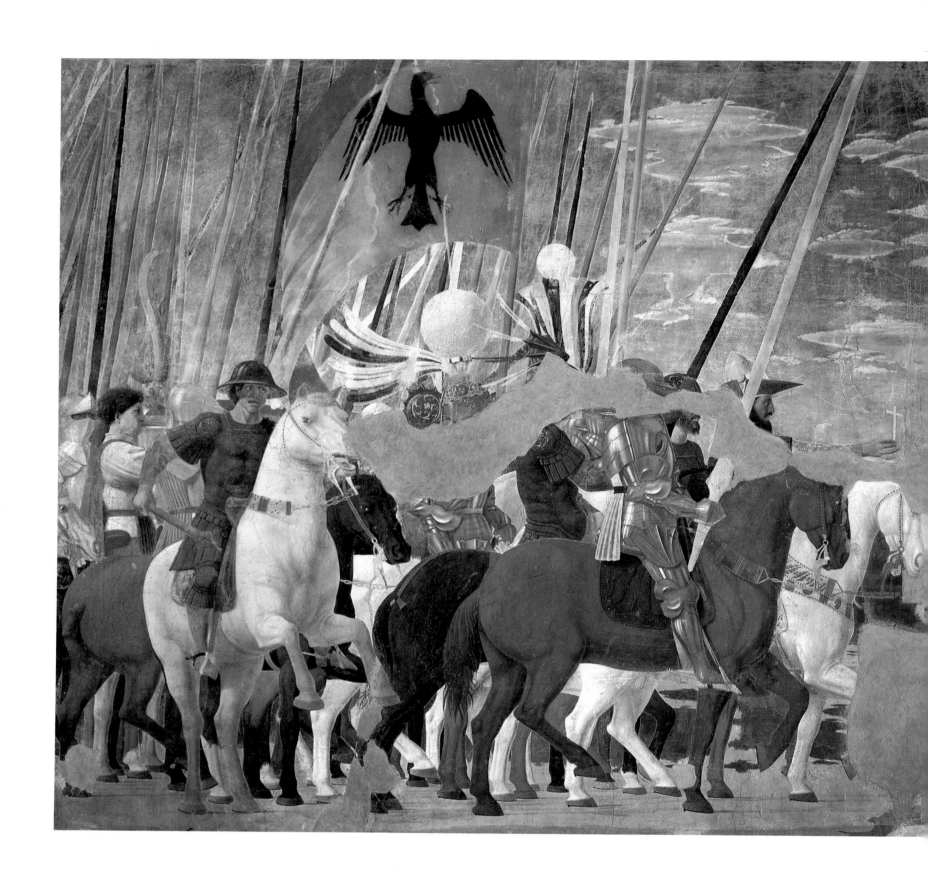

8. *The Victory of Constantine over Maxentius.* c.1452–1466. Fresco, 127 x 301". S. Francesco, Arezzo.

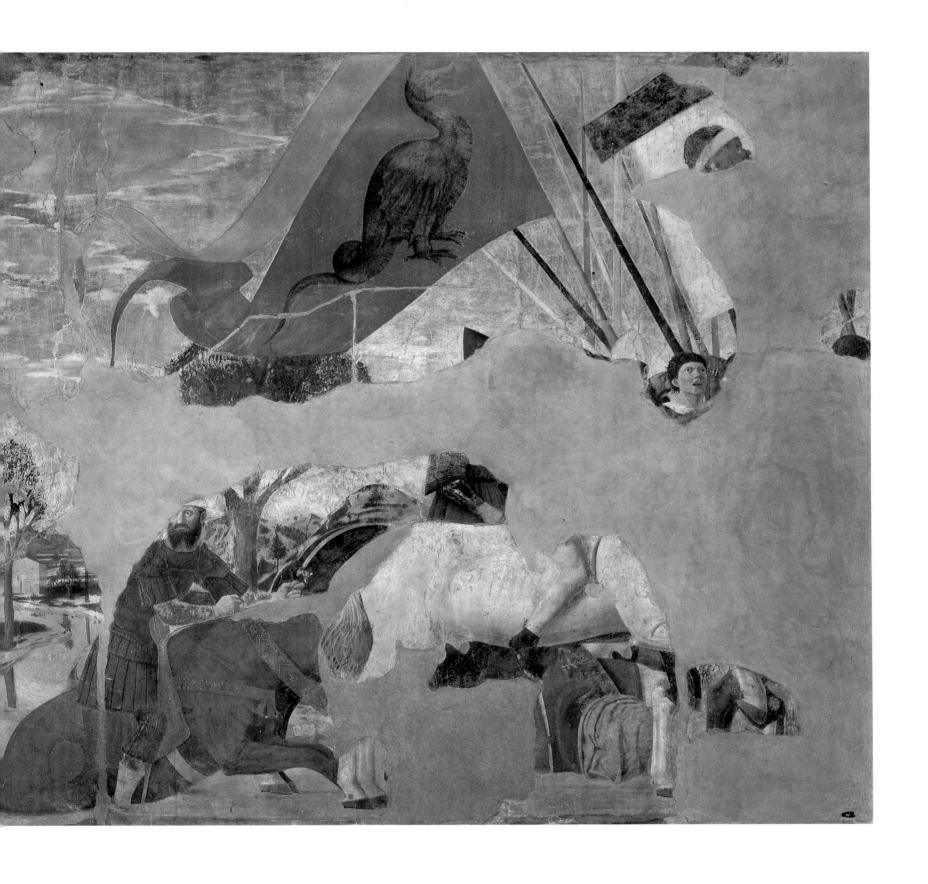

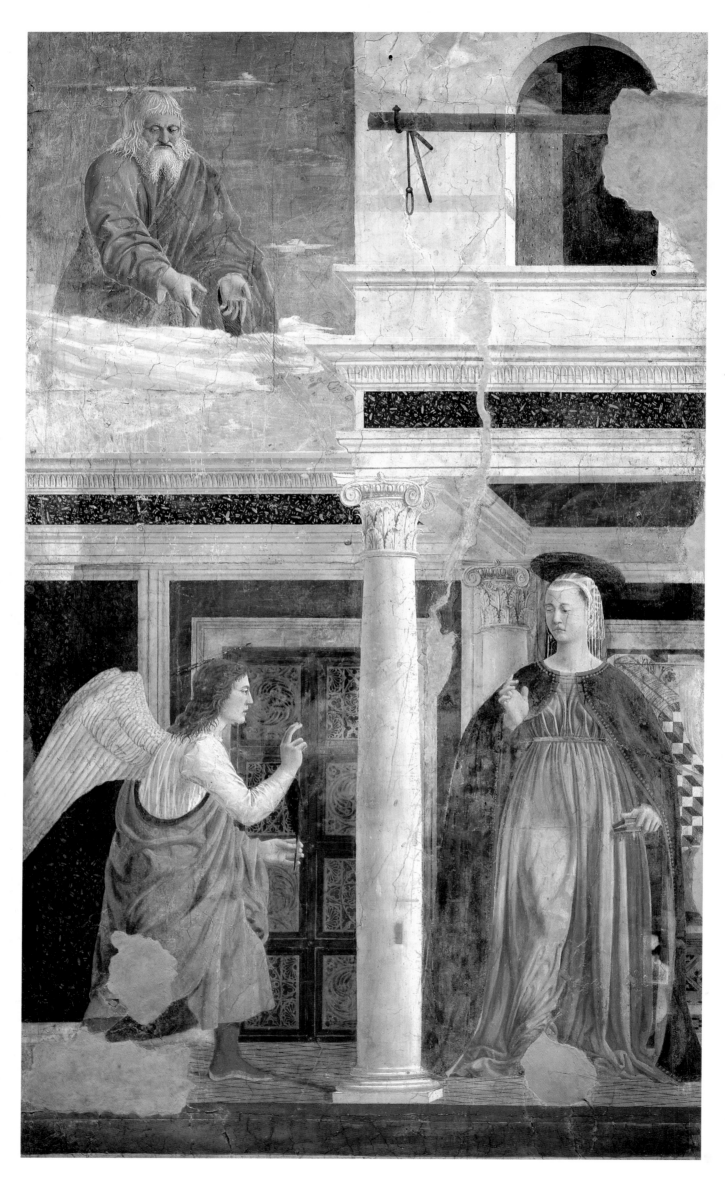

9. The Annunciation. c.1452–1466. Fresco, 130 x 76". S. Francesco, Arezzo.
Photograph courtesy Scala/Art Resource, New York

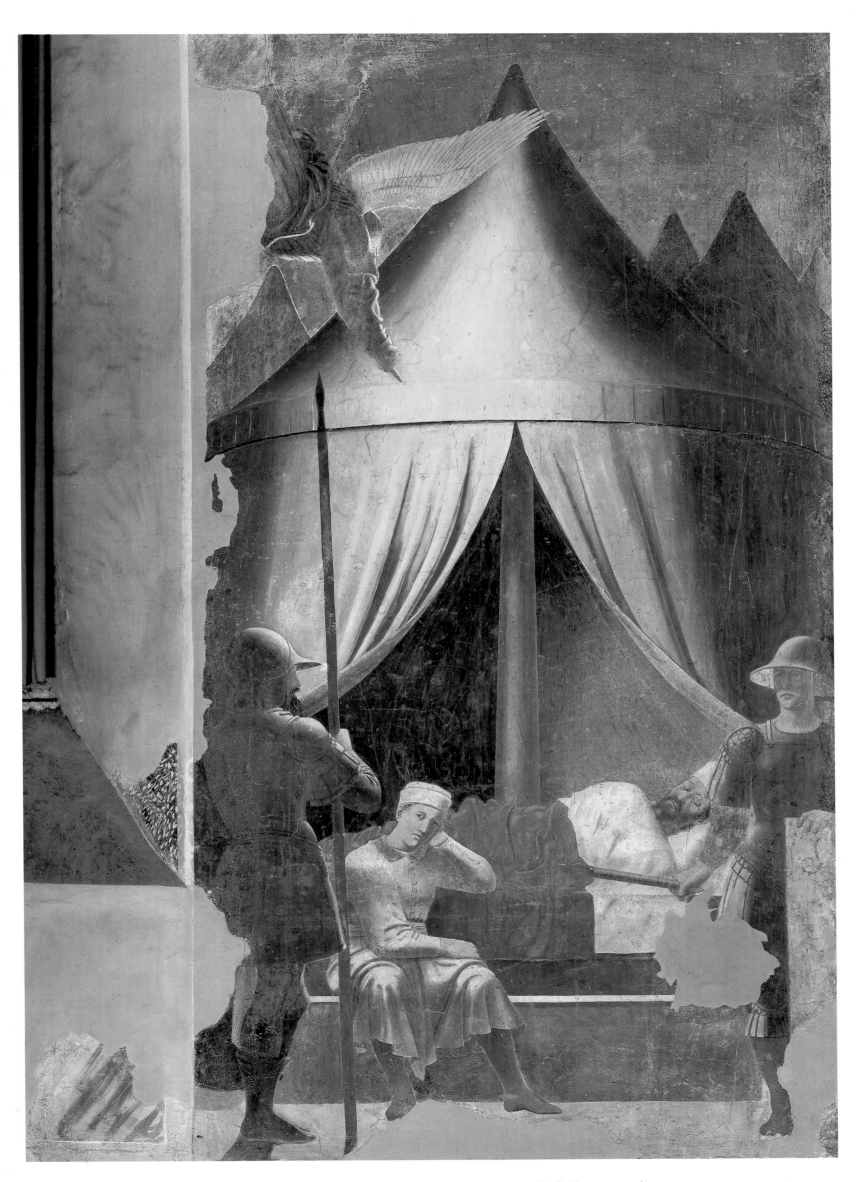

10. *The Dream of Constantine.* c.1452–1466. Fresco, 130 x 75". S. Francesco, Arezzo.
Photograph courtesy Scala/Art Resource, New York

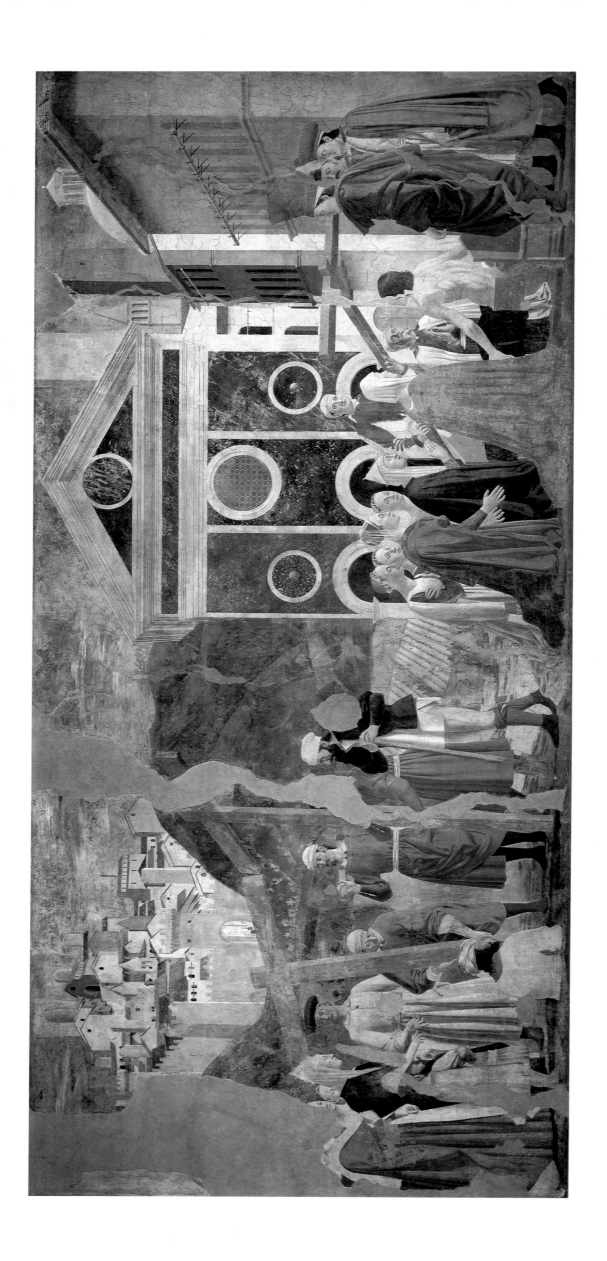

11. *The Finding and Proof of the True Cross.* c.1452–1466. Fresco, 140 x 294". S. Francesco, Arezzo.
Photograph courtesy Scala/Art Resource, New York

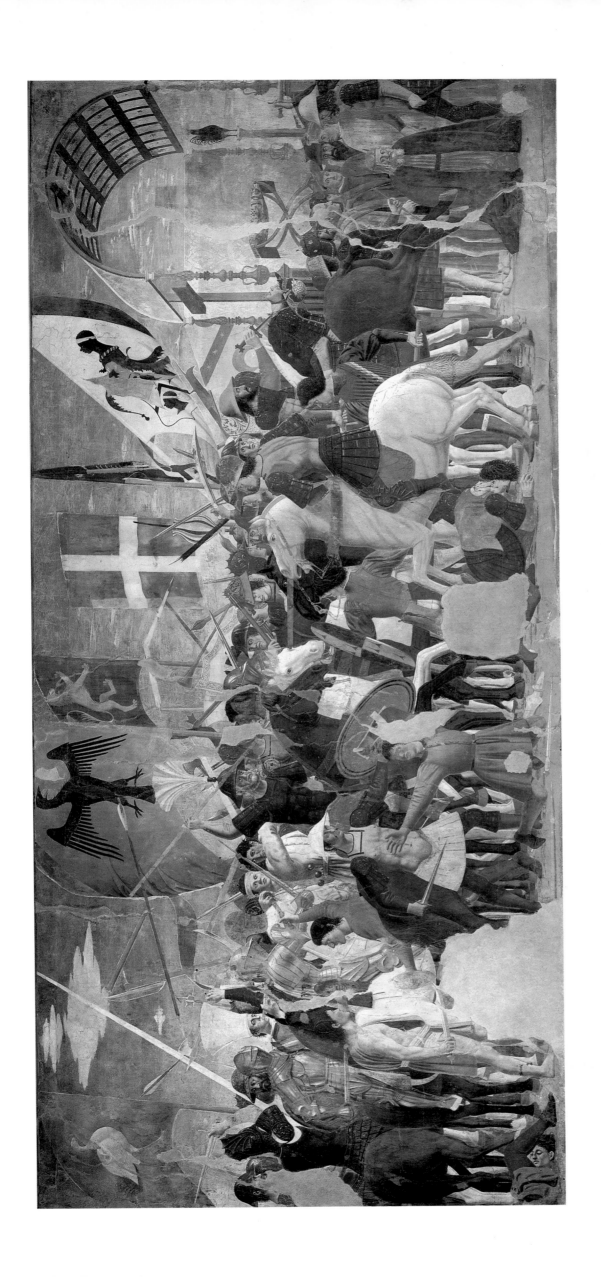

12. *The Victory of Heraclius over Cosroes.* c.1452–1466. Fresco, 130 x 294". S. Francesco, Arezzo.
Photograph courtesy Scala/Art Resource, New York

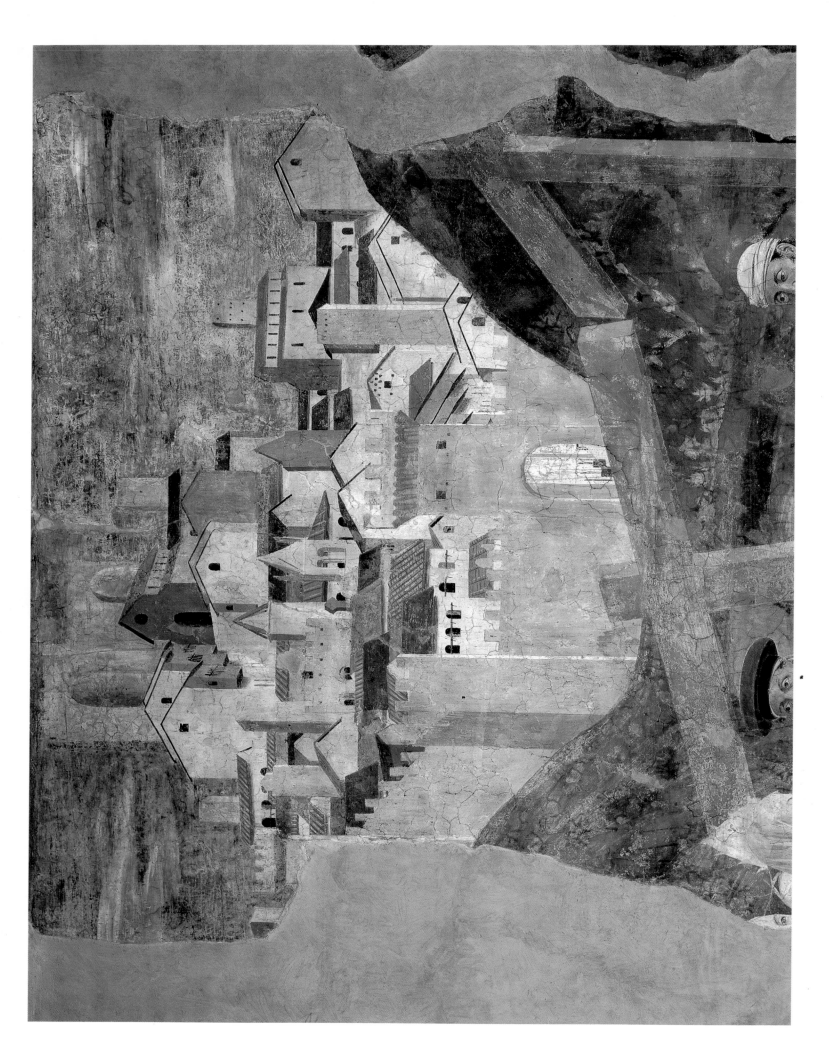

13. *View of Arezzo* (detail of plate 11).
Photograph courtesy Scala/Art Resource, New York